Advance Praise

"In this time of social media personas and the pressure to manage idealistic expectations of perfection, it is nice to read Shontra's candid recounting of her journey and learning in Proven Not Perfect. This is a must-read for anyone seeking a shot of confidence, inspiration, or encouragement."

—Wendy Selig-Prieb

"Shontra's words inspire and challenge us to push forward in life despite doubt and fear. She is a woman admired for her ability to pour God's spirit into others. She acknowledges that our struggles with perfection are relieved by God's grace."

—Brenna Huovie

Northwestern University Kellogg School of Management EMBA Cohort 100; Senior Business Leader UOP Honeywell; Member of St. Luke's Lutheran Church in Park Ridge, IL

Proven Not Perfect:

7 Truths of a Corporate Executive, Mommy, Wife, and Christian

Shontra Powell

The Do Not Limit Book Series

November Media Publishing, Chicago IL. Copyright © 2018 Shontra Powell

November Media Publishing info@novembermediapublishing.com

Ordering Information: Special discounts are available on quantity purchases by corporations, associations, and others. For details, contact the publisher at the email address above.

Printed in the United States of America

Produced & Published by November Media Publishing

ISBN: 978-1-7326897-2-5 (Print Copy)

First Edition : September 2018

10 9 8 7 6 5 4 3 2 1

Table of Contents

Dedication

This book is dedicated to those who believed in me when I was still figuring things out, and who had patience with me when I was messing things up... to you all, I am grateful.

Special love and acknowledgment to Andre, my rock on earth, Shella and Sam, my first guides, Sheleth, my first and longest friend, and Zoe, AJ and Sam, my reasons for trailblazing.

Much Respect.

"For the law made nothing perfect, but the bringing in of a better hope did; by the which we draw nigh unto God." -Hebrews 7:19

Preface

Pushing past anxiety and fear... taking the plunge of vulnerability ...

When I was inspired to write this book, it was made clear that I had a story to tell, and one that would resonate with the journey that many of us travel. We are many things, but balanced is not one of them.

I have never made seeking balance my goal; in fact, for me, it has been quite the opposite. A lack of patience and extreme drive has granted me highs and lows, leading me to my new truth: success... skills + heart = Impact.

This truth came with the price of experience, and I am extremely grateful.

Some of the key lessons I learned...

1. See people and situations as they are

2. Stay true to your inner conviction and truth

3. Seek peace in your decisions

Up to this point, my goal was to rise to the top of an organization. After reaching "the top" with my old truth, I took a 7-month journey to define my new truth. I am excited to tell you all about that journey, and my Mecca, in my next book, **"Do Not Limit Me"**.

Also, I look forward to connecting and staying in touch with you on social media, as we likely all continue to prove that we are not perfect.

Peace and Blessings
Shontra

Introduction

This story is ready to be born – seven years from the date of original inception! In these seven years, I returned to a corporate leadership role after obediently listening to the voice of God in my life.

Let me back up and tell you about the season before the story. I was at a crossroads. Would I… Continue the path of career and corporate success, doing so, however, at the cost of my family?

OR

- Give up what had somehow become my identity and self-worth, the pursuit of success climbing the corporate ladder?

I am grateful that I chose the blessed path to let go of corporate dreams and instead focus on my family, which, at that time, included my daughter (five years old), oldest

son (six months old), and my husband. It would be nice if I could take credit for being so evolved in faith and family to see the blessed path without a catalyst, but that is not my story. My story found me completely unavailable and oblivious to the needs of my family, and it took a severe virus overtaking my young son to stop me in my tracks. I am forever grateful for the prayers of my parents, which not only covered me in my youth and early adult years, but set me on the foundation that I would require to be grounded in my decision-making at that juncture in my life.

In my season of rest from corporate ladder and career, I was drawn to my church and to a journey of understanding my purpose. I explored all relationships and myself. I was thirsty for books that would teach me how to be a better Christian, mother, and wife. I immersed myself in church courses and enjoyed the Purpose Driven Life by Eckhart Tolle, as so many others were doing at that time.

I employed my leadership and management skills in the children's schools, quickly assuming leadership in the PTA, go figure... ☺. Also, I sought other women with professional experiences who had managed to choose the same lane that I had. I found support in these friendships and organizations. My family was healed.

I became inspired to rev up my business engine and decided to sit for a continuing education course. In the first night, it was clear to the teacher, and me, that I had more to offer than to learn. I was approached to serve as a growth consultant for the school's partnership with the state and industry businesses to invest in the education and sustainability of a class of minority-owned businesses. This led to more consulting engagements and eventually to a partnership with a friend and former colleague to consult for our former employer for three years. During that time, I enjoyed the intellectual challenges of building strategies, delivering innovation, and managing large initiatives for this firm together with my business partner and friend. My family grew as well to include my third child, and second son.

I am convinced that my obedience in that season was legacy setting. And I did obey, even though my human mind couldn't comprehend how I would recover a career after willingly leaving one that had me learning from top leaders in the corporate world, and interacting with amazing minds in key business initiatives globally.

BUT GOD!

In 2007, He led me back into my corporate career, and at a level that would imply that I had not left!

In 2010, back in my corporate journey and eager not to lose my family or myself, I was inspired to write *Proven Not Perfect*, and I did. However, I tucked it away. It was not time to tell this story.

Until now… seven years later. It is time to birth the author in me and embrace the amazing ministry that awaits.

May God Bless You and Your Journey – stay aware of your own crossroad opportunities to be blessed!

CHAPTER 1

❦

Inspiration

Proven Not Perfect

Perhaps today is a very fitting day to begin a journal that has been inspired, planned for, and in the development for years – forty. I did something that I rarely do – not so much because I don't want to, nor because I don't think about doing it – but because I am just like you:

Driven, focused, searching, seeking, and hopeful…

If you share any of these adjectives with me – at any time – then I encourage you to enjoy your own self-reflection and appreciation through my journey. In this journal is a peek into the life of a woman who is forty years proven not perfect AND forty years certain that God has inspired and anointed my life. He has placed tests along the way, gems in the most unlikely circumstances, and angels as an appropriate guide and protector through it all!

So, why would today be a fitting day to begin my journal? Today, I was forced by sheer lack of energy, strength, and will to remember that we need – require – down time. It is so hard to employ such a simple rule. The demands on our time and day are greater than they have ever been.

Information is so quick and available – of course we are connected... This is a "new" requirement for anyone interested in "knowing." And even if you prefer not to "know," the decision to disconnect can come with a price – you missed...you lost... Or you now own (what you didn't want to) the thing that someone threw to you in a "cyber world" to eliminate their life of wasteful, non-useful information.

Is this the game? Know it faster – to pass it on quicker... eliminates increased demand(s) on your time and resource. In fact, it is all quite similar to a game of volleyball, but with a different rule.

In this game, the object is to stand at attention on your side of the net (praying you've armed yourself with appropriate net blockers to prevent the need for you to move and volley) – and should you need to move, you must make it so that a mere punch of the arm in a powerful move is all

it takes to keep this "cyber world" from plowing into you again – this time with even greater demands, expectations, and items that consume your focus, taking you off path from your goals…and dreams.

Stop!!!

So, back to my today, I wish that I could claim that I stayed at home to take a mental health day because I appreciate the opportunity to be refreshed and rejuvenated – as a standard practice – but this wouldn't be true. The truth is that I have worked myself into a ticket to the doctor, winning the grand prize of a: sinus infection, bronchitis, and the threat of pneumonia.

Why do we miss the opportunity to care for ourselves before an event occurs?

Do we assume that God really intended for us to be creatures of the day and night – certainly in His perfect way, He must have known that we would figure out that He really intended for us to make 24 hours just the start…not!!

The opportunity for me (us) today, and every day, is to remember the feeling of rest, from the natural way that

one's body engages in the moment of shutting down – ill – requiring rest, overtaking any ability that we may have to offer any alternative option.

I am a wife, mom of three, business executive, community worker, board member, church parishioner, daughter, sister, and friend. At any moment, one or several of those roles have placed more demands upon me than humanly possible. Why do I allow this?

Because I love –

The feeling of accomplishment when a task is taken, completed, and rendered... is a success. The joy you receive from others when you deliver a value to them that could not have been achieved without your special, God-given gifts, is priceless.

I wrote this *poem* meets *memoir* meets *lessons learned* meets *devotional* to share a portion of my journey. My hope is that my stories bring blessings to your life. Before I get started, I should warn you, I am not perfect. I love the Lord, and I believe that His Son, Jesus, died for my sins – and now through His life and death, I am blessed to live (pursue) daily a new opportunity to seek a righteous life.

I believe that I can do all things through Christ Jesus who strengthens me. I believe He inspires me daily. And daily, I ask Him to lead my day, inspire me to be blessed, and to be a blessing to others.

Now that I have offered my disclaimer – know that I am walking and learning daily. These seven "truths" will allow me to capture, reflect, and communicate God's Amazing Grace and Anointed Way for those of us who settle for nothing else – while understanding that it is not easy to be at the front pew all the time! And do you really want to be? Instead, I'd like to be real!

My Inspiration...

Creating, building, and growing things!

When I think of my legacy, I get motivated by the fact that my great grandfather could see past oppression and encourage others to follow his lead to invent, design, and own his own future. He demonstrated courage, conviction, and clarity in making things move from vision to reality. The beginning of my story – living legacy of Clyde Hutson Sr. of Liberty, Mississippi, was the NAACP secretary for the local community. This incredibly inspired and active

leader in the Civil Rights Movement of the 1950s helped to plant the seeds that would lay the foundation for the work to come in the 1960s.

I draw inspiration from my father, Sam Morris (distinctly with no middle name), who fought his own battle against the norm and sacrificed to be a safety and security provider to his family. He colored within the lines and was self-made into a keen businessman and operator. His intuitive sense for systems and people is truly unmatched. He would ascend to levels of leadership and impact in his industry and touch people around him in a special way. His circle is large, and given his kind and pure heart, he is admired and appreciated.

I draw inspiration from my mother, Shella (Shirley) Taylor Morris, who, along with her siblings, at the age of nine years old had to deal with the loss of her dear mother, Edna Taylor. My grandmother must have been a woman full of beauty and grace, because my mother embodies these traits with only nine years of imprint. My mother's strength and grace are coupled with great drive and ambition. She did it all! She seamlessly flowed between the tough roles of mom, wife, student, mentor, teacher, and

homemaker.

I am singing in my spirit when the leadership of my grand-father, the discernment of my father, and the creativity of my mother join up within me to bless others and to create better things, or make things better.

I am particularly passionate about planting seeds for the empowerment and growth of women in leadership and business.

Thought Instigator…

Bring to mind your source of inspiration and power. Is the source internally driven or externally driven? How frequently are you tapping in?

CHAPTER 2

Confidence

Give It All You've Got

I was too tired today, and I didn't have it to give…

We often prepare for our experiences in life with study, rest, and training, among other things – basically, doing whatever it takes to be ready to present ourselves capable and ready. We all get this –

However, what about those moments when we are injured or challenged by illness, lack of resources – anything – and don't feel capable of bringing our "A" game? How do we get through those times?

Let's give this some consideration, since it is at these moments that we are allowed to learn our "true" character right "at that moment in time."

I want to make note of my deliberate statement of "at that moment in time" – you see, a big revelation for me is the

fact that as a believing, growing woman of God – we are on our journey of learning God's truth for our life – one experience, interaction…and day at a time. So, it is with this in mind that I remind us (me and you) that our character – by the very nature of growth – is in development. Character, meaning the attributes of one's self, is evolving from a genuine desire to be better tomorrow than you are today. Said another way, as a woman pursuing a *Today* Christian walk, we *aspire* to be righteous like the Psalm 31 Woman, but many of us leave the day wondering just how far we remain from that impressive goal. Nevertheless, it is *this pursuit* that has us evolving our character daily.

Building one's self on this journey, if we take it as an evolving proposition, can lead to how we "play" injured.

You see, your natural inclination – without effort – is to go back to your most recent recollection/experience(s) to find the guide to make it through your current experience(s). And if, by general principal, you keep certain values at the forefront of how you operate, these will be the known principles that you recall and pursue when you have very little energy to pull any bit more from within.

Practicing *what you prefer* can lead you to "giving all you've got" in spite of yourself.

We can sharpen ourselves by not only taking particular note of our behavior, but, most importantly, from the response that we elicit from others. You've heard that perception is reality. Well, I want to bring this simple truth back, but with a new swing.

My real self is defined by your response to me... One more try... If I do what is natural and right "feeling" to me, and you don't engage, then what was "natural" was not "right." To be right is to be effective in delivering:

- A valued offer

- A helpful perspective

- A joyful response

Take note – value, help, joy are all defined by the receiver and not me – could this be???

If I now step back and develop a real understanding of my behavior, I may find that I have more fruitful relationships in life. Ultimately limiting my deliberation on complex re-

lationships and increasing my capacity to do other, more productive things. Is this the truth of the Psalm 31 Woman? **Did she know that if she fully understood "what" was required in giving of herself in all situations, and therefore delivered precisely to the expectation – she would increase her effectiveness in business dealings, family, community…and health!**

What if we adjusted our thinking to be more focused on our self – giving in just this way? Would we be more competent in "giving all we've got"? And – would we be prouder of the outcome that we experience in sharing our gifts with the world…

I wonder!

My Source of Confidence…

I am reminded that even in my toughest moment, the Lord has me, and He makes this clear with my every sigh, breath, interruption, confused thought, and sight!

I have learned to "call out" the enemy of my confidence…

- *Allowing others to create an urgent situation* – instead of managing my response, I go with their urgency.

My combat: to listen, assess, and act only when I have peace and conviction rather than emotion driven by someone else's stress.

- *Not taking time for prayer and meditation* – because I have no "extra" time. *My combat: to dedicate (set aside) time daily, with intention, for quiet meditation, exercise, and writing.*

- *Managing an emergency that "just is"* – *My combat: act with God's centering, focus, and an attitude of readiness. Set a vision on the timeframe, and make space to reset and then rest.*

Thought Instigator...

In order to combat our enemy, we must know our enemy. Call out your enemy to maintain your confidence (and balance) in pursuing your dreams.

CHAPTER 3

Drive

Let's Go Get Ice Cream

It rained all last night – stormed, actually. It was the kind of storm that shakes the house and unnerves even the most unshakeable person (or demeanor). With every sound of thunder, every lightning streak – the rain poured. Constant drops with a purpose, cleansing and nourishing even the overly nourished basements. And then, it was calm.

Daybreak!

I began my day thinking about the frightening sensation of the night before and marveling about how the new day's beauty takes over and reminds us of the PURPOSE that even this experience had. Amazing!

Likely, I was not the only family member awakened the night before, because I met my daughter in the hall and

learned how tired she was…less motivated to get ready for her camp that "day after." Right off the tongue, I tell her that at this moment, she has a choice… Today can remain a chore, OR she could PURPOSE herself to know that the new day was certain to be the best one for her yet.

How do you PURPOSE yourself to deal with anger?

I had to test my own approach earlier tonight. It was really quite simple – I found myself feeling misunderstood, overlooked, and irrelevant by another (in this case my husband) all because I wanted to turn left and he PURPOSED "us" to turn right!

The feeling of anger is a complete agreement that you have lost control of the situation. You no longer understand how to make the next move, or yield any fruitful result that will appease you. Instead, you linger in this place of disbelief, that any other person would not fully agree to your point of view.

To deal with anger, it goes back to purposing yourself – and not another lending you the right to be in a place of comfort to you.

What I learned is that when I PURPOSED myself to that place of comfort, no other can resist trying to join me.

Just like going to get ice cream. My Happy Place!

My Drive...

How did I develop into the leader that I am today?

I did so by articulating my ambition and being fearless in my pursuits for ever-increasing professional experiences. I watched my managers and leaders like a hawk, and from each of them, I discovered the traits that I wanted to keep handy in my personal toolbox, as well as those that I wanted to keep in my file cabinet under "absolutely never do." In working to stand out, the goal for me in completing any task (large or small) was excellence. I would literally pose the question to myself: "How can I get the assignment done as asked, and how can I make the deliverable better than expected by the requestor?" The key for me through it all was faith, courage, confidence, and sacrifice.

> *How have you worked your way into a leadership role as a female working in manufacturing/technology environments and businesses?*

I would highlight the fundamentals and lean into them all the time. For me, this was to always be aware of my unique offer and to be clear on the need for my offer in a given situation/environment/role. I would look around and work to build a community of mentors and sponsors, allowing me to seize growth opportunities with the knowledge that I could fail safely.

Articulating our unique offer can take time and experience. When we start our career journey, we are typically in one of several positions – analyst, representative, level-one technical professional, etc. – and while we are able to get our job done well, it can take some time before we articulate what sets us apart and creates our unique value. For me, this would come over a series of industries (insurance to financial services to healthcare to manufacturing…) as well as a series of roles (account management to risk management to mergers and acquisitions to general management and leadership). With each assignment, I learned not only what I liked to do, but I learned what I am natural at… Spend time here. Self-reflection on at least a quarterly basis to uncover your recent experiences and where you naturally stand out helps to shape your understanding of your "unique offer" and story.

Always ask questions (of yourself and others) to be sure that you see value in the role that is before you, as well that you see "your" fit. What is driving the importance of the role today – a new problem? Do you have early vision about what is missing and inspiration about what can be? How invested is the company in your success…? Can just anyone get this job done, or do they see you as possessing a unique offer, specifically for the assignment at this point in time?

So much is timing… Be ready and have the courage to enter new areas when "the call" comes.

No one is born a leader – in fact, some aren't born to lead.
When did you discover that you were born to lead?

I discovered this when I failed at my first assignment to lead a team – a 200+ employee organization with five leadership direct reports to me. I went into the role with the mindset of an individual contributor. I knew my motivations to succeed, and I assumed – naively – that everyone on my team and in my organization would share these. After only three months, I was the leader, but few were willingly following me. It was all about me! My vision, my ideas to execute, and my desire to win! I was forced to look in the mirror and "grow up" when I lost leaders and my

best team members. I got it! I fixed me and leaned into the people and my purpose to serve.

I would confirm that I was a leader, born to lead, when I noticed that others were interested in (asking about) what I had to say. This was a direct correlation to me growing to understand what I consider key principles of leadership:

1. Be a servant – in the trenches with your team, never leaving them to stand alone

2. Have a purpose bigger than yourself as your reason to lead – a bit cliché, but it is "not about you"

3. Stay honest – humility and candor as a norm

Looking back throughout your career, can you cite the one or two things that you wish that you would have known, or were glad that you did know, when beginning your path as a leader?

Be humble, but don't misunderstand that humility should not compromise your presence, position, and impact. Acknowledge your unique attributes.

Thought Instigator...

How content are you with your environment and your impact on it? If you are content...why are you? Have you surrendered or, worse, lost vision? If you are not content...how long do you choose this for yourself?

CHAPTER 4

Fortitude

Through It All – Run

"On a train heading to a conference, one more week away from my family. Feeling encouraged, seeking God's hand to hold this day that I am less sure that I can focus – living on hope…"

A commitment is a commitment, and perhaps there's no better one to make than to one's self! Often, as we live our life with its multi-dimensions and expectations, it is so very easy to become overwhelmed.

And isn't it so funny that you can start out on any new journey feeling confident, prepared, and encouraged, but somewhere along the way, your footing seems to slip, and you forget to breathe – listen – wait patiently…and to focus only on what matters.

So much can, and does, come at us all at once that it truly becomes a part of the song to have the temporary introduction of loud, clanging noise that breaks the sound of your otherwise smooth jazz – flow and experience. This describes where I have been the last several days: jogging between the ideas of being in control and being stranded in a melody that doesn't fit the song that I am writing – quite simply, off my game!

Work – a loop of misunderstood intentions and phrases that require more work in managing the message to fit my intention.

Kids – school starts again in less than one month, and I feel unprepared as a mom: supplies, clothes, visits with kids' schools... Prepare the kids, prepare the house...

Oh yeah, how about the house and the new gap created by three kids in three different schools – searching for help BUT never wanting to relinquish the comfort and safety that you only get when YOU are doing it for your kids!

Yet we press on – trust that God will deliver the gap fill that we need in nurturing and caring for our kids. This IS normal.

Husbands – they have dreams! They need us to listen, love, and support them and to fertilize THEIR seeds…

Family – baby sis (grown woman) is pregnant – baby number one – three months! So thankful and happy! With more time in the schedule, you'd be on a plane, BUT life… Now complexities and commitments take our ability to do the little things in the moment…

Community – I would love to give more to that committee, to do even what is timely, but somehow, the glass got so full-up that triage had to become the strategy – life management…you need a plan.

What is little…is little more than insignificant

What is big…well, you'll just know!

In all this, I run, and I build my body, mind, soul, and spirit. It is these moments of personal challenge that I experience the source and strength that lives within me. With each breath, I acknowledge the labor – with each mile mark, I honor the footsteps that got me there. At the conclusion, I pray! I thank God for the hope that allowed me to believe that I could run (far) – and I praise Him for

the testimony in the experience. It is His Grace –

When life is running around me – I recall the strength in my run. I note the last footstep that kept me going/pursuing – I honor the gracefulness that prevailed in my actions by lesson. I give honor to the Almighty, and I know that I can and will run!

How I Think About Fortitude ...

It is a gift to oneself to appreciate your own feelings. Our feelings are our best guide to the needs of our mind, body, and soul...

I have learned that my mind needs to wander from a project, assignment, or task in order to be revived with the energy to think clearer and with eventual success in completion.

My body needs to flush itself of all things synthetic to allow a firmer understanding of what it truly wants to respond to as a thoughtful external expression.

Should I move, or should I stand still...? Can I push, or am I on the edge...? Can I push the edge...? Is my soul well...? Can I sense the spirit that guides me, or have I lost

touch with the spirit because I am going too fast to note its presence…? Am I grounded in where I am headed, or have I lost my way…?

Thought Instigator…

How often do you find an alone place and check in with yourself?

CHAPTER 5

Humility

Honoring Ourselves in Honoring Others

How important a gesture can be – simple to the giver – but life changing to the receiver. We all have that innate need to love and be loved, or appreciated for who we are as well as what we offer.

I recently had the opportunity to develop a script to honor a group of ladies that held a high office in an organization of which I am a member. I didn't take this assignment lightly, because it was clear to me that my words would represent the truth for them – meaning, if it fell short of expectations, it could be insulting instead of uplifting…

We spend so much time defining ourselves to the standard of another. We spend too little time noting the voice within us, defining that which brings us joy.

I will listen to my inner voice today and honor myself.

My Humility...

Begins with the realization that I am unique and specially purposed for something...and my journey is to uncover what, how, when...and to get to the highest place of using everything that I have mastered along the way, harmoniously, for good.

Thought Instigator...

What is your superpower?

CHAPTER 6

꧁ ꧂

Optimism

So, This Is the Day and the Time

Putting forth work – hard, focused, patient, and unrelenting work – on anything for a season can be depleting – mentally, physically, and emotionally.

Through all of this, the one preserved strength can be your spirit. If you are of God – a professed child of God – He will never leave you. In fact, as all the human factors become depleted, the spiritual being can be more enriched and ready than ever before. It is important to understand the race:

As a runner knows, there is a point that you can *push* your body and another point where you must *honor* your body and *rest* your body, maintaining your long-term ability.

I believe the spirit pours in at those moments of physical weakness and fills every gap of weakness with new

ability – before you know it, you are appearing more fit than ever before, more beautiful (inside & out), radiating peace, more mentally focused, and more physically capable – thank God!

Looking back on an eight-month journey, I reflect with joy...

I was not always at my best, but when I fell the hardest, the Holy Spirit lifted me up with new understanding.

When I was hurt the most, the presence of Peace surrounded me as a blanket of Love and Healing.

When I sought to get ahead of myself (and others), I was coached back in line and in order with God's will for me!

My family smiles and sings in this – my growth journey and victory!

My Light to Stay Optimistic...

You won't like every class/subject, nor will you like every teacher; however, you will learn just the same from both experiences. I have recently heard this called the "craftsman mindset." Set out to do everything well and then

leverage what you know.

Loved these jobs… We can all state these with passion.

Hated these jobs… If we are honest, these were the medicine that we needed…

Just like in school, you inevitably walk away liking the teacher that you hated at the start of the year and being more realistic about the one that you professed to love.

So, why do I think the craftsman mindset is key, how does it work for me, and why is it important?

1. Learn to dig in and grind it out… I focus on what I can learn and how I will use it to be better.

2. Learn to check yourself and adjust… There is always something that I am doing to get in my way. I call it out, own it, adjust, and excel.

3. Be joyful… It is really never that bad. Recognize that there are peaks and valleys. When in the valley, it is easy to get stuck in complacency or contempt for a less-than-perfect situation. So, what I do is pretend until I believe it myself – the truth for me

is it's not too long before I realize that I do, in fact, believe.

Thought Instigator...

It is very interesting to me how we can be so close to a breakthrough and lose our heart and intention. It seems that we can be wooed in this journey – thus requiring us to be aware that this can happen.

Have you ever been so excited about something that you had worked for and planned for only to get to the event and find that your emotions did not seem to line up with the excitement that you thought you would feel, making the actual experience seem less tangible than you had hoped it would be...? What happened?

We can place such weight on the achievement that we make the experience supernatural, and therefore make it harder to relax and "be" in that moment with the realistic expectation that it is another moment, one of several that you can have on this journey. With this consideration, couldn't we be more "in the moment" than we are?

In my plan to live more on purpose, I am working on being where I am, working to affect what I can, and expecting

richness in every new day's offer to me.

Set goals – yes!

Work to reach goals – yes!

AND

Planning and preparation leads to peace in the day's offer.

CHAPTER 7

Courage

Doing All Things Through The Strength of Christ

"The words upon the conclusion of an intense leadership development experience – reflecting on: what just happened?"

An eight-month journey with a team of folks that I knew not last year at this same time…

I entered this experience knowing myself, believing in myself, and confidently displaying myself –

I leave this experience acknowledging myself as an individual among others with unique offerings that come together to create a harmonious symphony of success in pursuit –

What a joy in the journey, what a peace in the new still moment that I haven't known since before I knew this mo-

ment. The Amazing Grace of God and design architecture of His wisdom!

My Secrets About Courage...

1. Be present where you are! Don't get trapped in thinking too far ahead too soon.

2. In the world we live, we have less time to prepare, so pick the important areas for you with clarity.

3. Be ready to make a choice on priorities, and be ready to trade with discernment.

4. Faith really does move mountains!

5. **Be on a Mission always**

What does mission mindedness mean...?

The realization that who you are when you show up matters. It is more than just what you need to accomplish a thing; it is also how you plan to do so. In short, people matter, clarity on situations matters, willingness to slow down to go fast matters. We should remain present in the short term, but focused on the long term.

Spend time with yourself – quietly, discern your source of energy versus your energy drains, your power to impact, and your methods to make this all come together.

Define your beliefs and personal truths – let this be your guide or ruler to see each opportunity as either complement to your truths or distractor from your truth. Be honest with yourself, because fit matters.

Seize your potential to be a force of change – don't count yourself out. Answer the call, but with clarity and intention. Keep your intentions clear in your own mind at all times.

Define the why and remind yourself of this when it gets hard. Life is a journey, and we need our truth for perseverance.

Thought Instigator...

Are you on a mission?

Made in the USA
Lexington, KY
26 September 2018